A Window into My Soul

Adanna Rivera

BookLeaf Publishing

A Window into My Soul © 2022 Adanna
Rivera

Presentation by *BookLeaf Publishing*

Web: www.bookleafpub.com

E-mail: info@bookleafpub.com

ISBN: 978-93-95088-79-4

First edition 2022

DEDICATION

For Mama, the editor for all of my work, and
Angela who made me feel like I wasn't alone in
the poetry world

PREFACE

I toggled with the idea to publish a book. Over
and over again as I paced in my room, the idea
just wouldn't leave my head. Writing is a gift
and a skill, and until I went to college, I never
thought of myself as a writer. Sure I've read
story after story and poem after poem.
Devouring their words and engraving them into
my memory I never thought that subconsciously
I was introducing myself into the world of
writing. This is my first publication of many,
and I hope you enjoy it!

iced coffee

His wit brings out an old side of her
The kind who will laugh until she chokes
She snickers like a teenager
Oh, how lovely it is to love
After many months and moons
Of longing for a companion
Of being so settled with herself

She cannot bear the thought
Of having someone besides her
As she had pondered many a time
About whom else could be by her side
To replace the hole of heartbreak
Right when she had given up on love
Is the same moment she found it again.

In the glances between them unseen
In the tone of his questioning voice
In his chivalrous motions toward her
In his expression of deep concern
Though opposites among the stars
It is fate's celestial attraction
That makes their love stronger evermore.

an ode to writing stories

Sometimes when I think, "Am I meant to write?"
I introspect myself and reflect on my memory
Every piece of literature I have consumed
Every film I have sat through
Every story I have witnessed

I have always been drawn to play-on-words
How it can change a phrase entirely
Adding onto the layers of meaning
Forcing readers to question their morals.

I have always admired books
My fingers have met with their tender pages
Admirable characters with their wit
Their words tear my heart to shreds

I have always been drawn to the craft
Solely because of them
Our connection is unbreakable
As they pull me into their world, I forget myself

I believe it is how I write
How I introspect and reflect
As I watch and observe them

Analyzing their every move

Perhaps it is the creative's mind
Waiting impatiently when a story is told
Instead of reading them
Sometimes I must finish them myself

My pen meets with my hand
In the gap between thumb and pointer
It scratches the paper furiously
Until my eyes strain, my wrist cramped with
pain

Sewing the shreds back together
Into a new creation of my own
I have healed my soul once more
And I know I am meant to write.

modern romance

you text me first
a message ever so mundane
yet it makes my heart skip

flying down

High in the sky
Above all the land
Lights glow golden yellow
From every ventana
The island is alive even in these late hours
The towns are not conjoined as back home
Separated yet connected by bridges
I can see palm trees from up high
Wide stretches of green
Mountains so tall you could touch them
We are getting closer to the trees
The shape of buildings becomes clearer
I clutch my chest tightly
As fear clouds my mind
Hoping I survive in one piece
We are close to the ground.

confession

Isn't it ironic-
How I've loved you this whole time?
I loved you at that party
When I was tipsy from vodka
Dancing to get your attention

I loved you when I took us hiking
We walked into the park
Vacant with blossoming trees
Our eyes scanning through every branch
Comfortable silence between us

I loved you when we were on my couch
Watching one of my favorite films
You grabbed my hand
Laced your fingers through mine
"I can warm your hands", you said.

I loved you when I had to drop you off
I turned up the stereo
Blasting an Arctic Monkeys song
You laughed as I belted the words
Making a sharp turn down your street

I loved you when held me in your arms
My feet were too sore to carry me home
My hands intertwined around your neck
Right then I could have kissed you
Would you have done so too?

I loved you when you got your first tattoo
You pulled back your sleeve
My fingers danced over your skin
You did not even flinch
Even though it was still fresh.

Yet after all that you say you love me now
You just realized you loved me
After all this time
Babe, didn't you know?
You caught me a long time ago.

crushes suck

"Get out of my head!"
I scream at my steering wheel
You consume my thoughts.

jealousy

To think my best friend
Would not always be near
Her bloodline always comes first
It is childish to say
Too vulnerable to hear
Yet the last time we spoke
I thought it was a joke
When you said you couldn't drive in the rain
So, I smile and nod
My brain is nothing but fog
As I push down the pain.

Penny

Her legs match those of a horse
Long and slim as her
The wind flows through her ears
As she hunts a frisbee in the air
Her contagious energy shown
Oh, how big she has grown
Spots sheath her body
Turning to blurs as she sprints
One resembling a heart
As large as her love for us
Though she won't say it so
Since she is only a dog
Her soul is as human as can be.

people watching

Isn't it funny to think
Of the many lives
Who walks into the library?
Each with their stories
A reason for being there
Cram studies,
Group presentations,
Procrastinators,
Friends meeting before class,
Friends skipping class,
I am sitting in the lounge
With the occasional sip of coffee
As it burns my lips
My ears filled with sounds
Of keyboards typing,
Mouses clicking,
Glitching computers,
Pens scribbling,
One of which is mine
For my reason is
To catalog my observations
As I watch them move through life.

say the house is ours

As we dance in my parents' kitchen
The phone is playing instead of a record
My dad built this kitchen with his bare hands
Callused from the years of labor
Your hands are different
Softer, and smooth to the touch
Your long fingers encapsulate my smaller hands
You place them on my waist
As my arms intertwine at your neck
The way you gaze down at me as if we'd just
met
Half a year after and still
I have fallen for you every day since
Just as you have for me
Tomorrow, you leave to train
In case our country fought another war
The music sings on my phone's speaker
but in my mind, we are together
This is not my house, it is ours
Say this house and ours
and maybe it will make the goodbye easier
Say it is ours so that I am back in that moment
With us dancing slowly
Say it is ours because I wish it was
I wish it was instead of me here

Three years passed in my room
Writing about a love that once was
and a life that could have been ours.

Naila

Related by genes
Separated by age
I am grateful to have seen
Your growth at every stage.

We share the same curls
The same month of birth
Our dad's beautiful girls
One fire and one earth.

A lifetime apart
Eighteen years to be exact
You are still in my heart
Our bond remains intact

The time we spend together
In the water or the sand
Is what I will always remember
On the plane, before I land.

St. Augustine

My steps meet with the cobblestone streets
The streets where horses walk
Shops line the town extensively
Niche and varying in size
Every door is open to crowds
As they spill out into the road
Ancient colors and walls
Transports me to the past
As if it is not modern-day
Museums and graveyards
Spirits fly among them
Playing jokes on tourists
The bell rings from afar
At the old schoolhouse
The scent of coffee in the air
From the competing cafes
A trolley glides near me
Joyful music playing loud
There is the old bookstore
Owned by a wise, elder woman
Nearby the shop of soaps
Bright pink with embellishments
The air now smells of wafers
Where the singer belts rhythm and blues
I stop before a passing car
Just as I have reached the bar.

Sylvia Plath

How is it a woman so young
Her mind as quick as a whip
Can hold so much power in her hand?
The hand controls the pen
As it is pressed to parchment
The words burst freely with luminous life.
They could bring any human to tears.
Why did death have to arrive
Just as steady as that whip
Even when her mother tried to cure her
Was she too far gone?
When she was capable of such brilliance?
As if three attempts at dying were not enough
Perhaps her cry for help should have been louder
More elaborate than the last
How irritating it is
When a man tried to tear down her legacy
By hiding her work from the world
Perhaps he was afraid of her power
He knew what her words could do
How it could grip onto readers
As she has with me.
Religion is not present in my life
But God I hope He is overseeing her now.
An influence among women

She wrote about what it means
To be a woman in her time
To be vulnerable about her depression
Even painting images through her words
Like cutting her thumb instead of an onion
She deserves the notoriety
Even if it is decades past.

doubt

There's the voice again
"You will never live this down"
Screaming from my head.

i saw the pool today

It looked the same as back then
I was strolling along the beach
Thinking "could it have changed?"
Then I was standing in front of it
The rock is still in place.

Does he remember that day?
The film plays in my head
We pulled into the parking lot
The most vacant field
He walked ahead and I followed

I shouldn't have been with him
I shouldn't have gone with him
But something pulled me to him
We strolled along the beach
You wrote something in the sand

He looked up and pointed at something
The old, abandoned pool
Crumbling and surrounded by rocks
There was one placed in the corner
To be used as a stool to get inside

He climbed first and I followed suit

He firmly grasped my hand
As I swung around the fence
He caught me by the waist as I almost fell
To this day I wonder how we weren't seen

The pool was empty
The brick walls covered in graffiti
Messages to people
Couples engraving their initials
Political statements for all to see

I thought I should have brought my skateboard
So, I could take advantage of the smooth gravel
We sat along the edge of the pool
The inside was covered in moss
Birds sat inside pecking at the water

I lay on my back and my feet gripped the rails
Above me were pink, fluffy clouds
They could have been painted
He lied on his back out of curiosity
I took pictures of the sky and him.

We looked at all the messages on the walls
"Heart made of glass my mind of stone"
"Scars will heal, but we're meant to bleed"
"Live fast, die young"
He pointed out his favorites as did I.

I found the abandoned bathrooms
Daring him to go inside
just as he got closer, we heard a noise
A loud bang as if someone was there
He sprinted and I followed

We immediately left the pool
I scraped my hands climbing back around
We continued running down the shoreline
Until we were too tired and caught our breath
I laughed at his superstition.

I shouldn't have been with you
Because when we went back in the car
We left to go see a movie
He held me in his arms and kissed my neck
and I kissed you back when I know I shouldn't
have.

While I shouldn't have been with him
It is a heavy memory I carry with me
Long after he's been gone
Long after my partner and I are split
In the end, it is him that I miss.

rejection

My heart cracks in two
Shattering on the floor
If only then I knew
Not to ask for anything more

With the cold shoulder, you gave
I watched it all fade away
The butterflies now in their grave
I long for them to stay

You do not meet my eyes
When you do, they are dull
No glint left insight
They are sunken into your skull

How could I have been so blind
To not see your true plan
I am suffering my demise
It is foolish to love a man.

You don't even feel guilt
From all the lies you told
You let my blood spill
What a sight to behold.

subconscious

Last night I dreamt of you
You begged me for forgiveness
Your knees fell to the ground
I denied you many times

There we are in your room
It looked the same, nothing changed
Games that infiltrated your mind
Though many times you will die

I was there on your bed
With its plush navy sheets
Staring at the familiar posters
And the open closet of sweaters

You were standing by the door
Afraid to be near me
As if I were flames that could burn
If you are close enough

The room was the same
The one thing that changed
Was how scattered everything was
"It was cleaner when we were together"

I tell him this plainly
His head falls into his hands
Sobs escape his lips
He replies, voice broken

"It was only worth cleaning
when you were here"
I show no remorse
For how could I?

When he left, I longed to die
Cut my heart from my chest
And squeeze the pain out
Because it hurt every day since

Though I could not do this to him
It did not stop his knees
From falling to the ground
From approaching me so

This time, unafraid to be burned
His sobs turn into pleas
Pleas of my return
I did not feel for him.

When I awoke, I was numb
I knew it was all a lie
You would never beg for me
Not when years have gone by.

shirley temple

Crimson cherries float
You are sweet and red as blood
Ice clinks as I sip

admiration

The sun peeks through the shades
As I walk into the room
It must be fate that we should meet this way
Your eyes catch me first; blue to match the sky
Your smile catches me second.
To my heart, you are tied
Sitting adjacent from one another
Yet you will never uncover
Emotions I am forced to contain
So while your looks do play a part
Your gaze ties my mind to a chain
To you, I am cuffed by the heart
Like coffee sprinting through my veins
It is you my dear
That makes a sound ring in my ears.

an ode to the moon

The moon is new
Discreet in the night sky
As the stars shine around her
Lost in the darkness
She remains unseen

The moon is a crescent
Slim peeking down
She is slightly revealed
As curiosity fills her
Her light has returned

The moon is a half
Almost as bright as a whole
She is perfectly sliced
Symmetrical in the sky
She is revealed a bit more

The moon is almost full
She is now gibbous
Not quite at bright
Yet not quite as dull
As if she is glancing to the side.

The moon is full

Lighting up my skin
She is hypnotizing
Entrancing me so
It is impossible to look away

She repeats her cycles
Through the week
Bringing energy each night
As the stars make way
Leaving space for her to glow.

better days

To save yourself is brave
It is the strength you have to find
It lies asleep, deep in its grave
For now, I tell them "I am fine"
The pain is nothing but frays
It is not something I hide
There is no black hole in my chest
The chest where love did reside
My strength is still at rest
And I am empty if you stare at my eyes
The rope has not been stressed
It remains on the side
It lays limp instead of tied
Then your mother walks in
She can tell you have cried
By the cherry, redness of your skin
"Is this how you will remain?" she says
With your hair slicked with grease
And your face unclean
Only cleaned when your tears stream
Wipe the sorrow from your eyes
And hold your head up high
Because this is not the woman I raised
You will come out stronger
If you hold on longer,
You will witness better days.